壱拾萬円也　竹中源太郎殿　和歌山市光泉寺旦

壱百萬円也　徳岡俊玉殿　北九州市栄林寺住職

五拾萬円也　若崎哲昭殿　山口県安岡寺住職

壱拾萬円也　林　ハギノ殿　小倉範院寺住職

参拾壱萬円也　称名院檀徒一同殿　西三二二

五拾萬円也　宝樹寺檀徒一同殿　京都市

五拾萬円也　柴田教順殿　半田市盤仁寺

壱百萬円也　金光院檀徒一同殿　京都市

萬円也　松林賢道殿　兵庫県日光寺住職

萬円也　小谷諦詳殿　田辺市正寿院住職

萬円也　本田俊励殿　北九州市阿弥陀寺住職

金壱百四拾萬円也　廻向院檀徒殿　竹橋市

金五拾萬円也　増田寿久殿　一宮市

金九拾八萬九千四也　正楽寺檀徒一同殿　和歌山市

金六拾八萬五千四也　立台寺檀徒一同殿　天田京市

金弐百八拾萬円也　安楽寺檀徒一同殿　行橋市

金壱百八萬円也　西生院檀徒一同殿　福岡県

金参拾壱萬円也　長福寺檀徒一同殿　相楽郡

金壱拾萬円也　古田リョウ殿　福岡県西生院旦

金参拾萬円也　神田光晴殿　北九州市水名院

金参拾壱萬円也　西光寺檀徒一同殿　長岡京市

金弐拾壱萬円也　阿弥陀寺檀徒殿　名古屋市港区

JAPAN

LANDSCAPE TRADITION SEASON

PHOTOGRAPHS
Mike Langford

TEXT
Gregory Clark

CHARLES E. TUTTLE COMPANY

Tokyo, Japan & Rutland, Vermont

Japan: Landscape, Tradition, Season

Published by the Charles E. Tuttle Company, Inc.
with editorial offices at
2-6 Suido 1-chome, Bunkyo-ku, Tokyo 112, Japan
and 77 Central Street, Boston, MA 02109, U.S.A.
by special arrangement with
Transworld Publishers (Aust.) Pty Limited

Photographs © Copyright Mike Langford 1991
Text © Copyright Gregory Clark 1991

Library of Congress Catalog Card No. 91-65713
ISBN 0-8048-1714-6

Designed by Maree Cunnington

Map by Trevor Hood
Typeset in Baskerville Light by
Midland Typesetters, Vic. Australia
Printed by Dai Nippon Printing Co., Hong Kong

(Endpapers)
Wooden prayer offerings at Komyo-ji Temple, Kyoto

(Half-title page)
A schoolboy adjusts his friend's uniform before having the
obligatory class photo taken near Kofuku-ji Temple in Nara
Park, Nara, Honshu.

(Page 2)
Miyajima in Hiroshima Bay, western Honshu. The rich
shellfish beds of Hiroshima Bay are exposed each year by
extreme spring tides and become easy pickings for the many
gourmets who flock to the area to make the most of the
opportunity.

(Title page)
A soft autumn rain brings out colourful umbrellas as a
group of sightseers walk over Kintai-kyo (Sash of Silver
Brocade) Bridge at Iwakuni, south-west Honshu.

(Following page)
A close-up of a beautiful bridal *kimono*

SEA OF
KHOTSK

SEA OF
JAPAN

NORTH
PACIFIC
OCEAN

Hiranai

Hirosaki

Tamagawa

TOWADA-
HACHIMANTAI
NATIONAL PARK

Kakunodate

Morioka

Matsushima

Yonezawa

Shiogama

Kinkazan To

Fukushima

Matsushima Bay

CHUBU-SANGAKU
(JAPAN ALPS)
NATIONAL PARK

Takayama

Adachi

Okayama

Nikko

Himeji

Ohara

HONSHU

Kakogawa

KYOTO

S E A

Nara

MINAMI (SOUTHERN)
ALPS NATIONAL PARK

Awaji Shima
Island

KU

Fuji Five Lakes

MT FUJI ▲

TOKYO

Fuji

Kamakura

JAPAN

A PERSONAL VIEW OF A UNIQUE COUNTRY

JAPAN 1961: Long days on local trains meandering through the burnt browns and yellows of a late autumn countryside. A mountain village under its first snow, with the deep orange of the *shibugaki* (bitter persimmons) hung out to dry under the farmhouse eaves. The cleanliness and architectural perfection of a simple *ryokan* (country inn). The shy charm of a young girl wanting to practise her English as a guide to the Kyoto temples. The meticulous attention to detail in everything from the train timetables to the packing of a *bento* lunch box. The diligence of a nation recovering from poverty and defeat in war. I knew then that the memories of that brief two-week visit would bring me back to Japan.

When I did return, some six years later, things were very different. No longer was I a government official studying Chinese and free to travel Japan at its autumn best. This time I was a university researcher stuck in Tokyo with a small stipend and just a year to learn the language, make contacts and collect materials. It was make or break in what, even then, was seen as one of the world's toughest and most exclusivist societies.

But slowly the breaks came. The large and famous university to which I had been sent proved to be just as exclusive as I feared it would be. But a 'professor' from a small private university took me under his wing and told his students to look after me. They helped me find accommodation. From my base in a small Japanese-style room in a typical middle-class Tokyo suburb I set out to discover my surroundings—the warm communality of the local bathhouse, the day-and-night bustle of the narrow, car-free *shotengai* (shopping streets) that radiated from the local railway station, the quiet of the temple grounds in which the children played, the *akachochin* (literally, red lanterns) or small eating places set back just

behind the *shotengai*. I say suburb but Japanese suburbs are very different from ours. In Japan streets and shops seem to fuse into a jumbled whole in which everything seems to belong to everyone. It is more like the urban village.

Gradually I began to discover the rest of Tokyo. We are told it is the world's largest urban concentration, containing close to 30 million people. But within one's 'village' one is barely aware of the city outside. Tokyo is really little more than a collection of these villages strung together by an excellent railway system. The trains feed into larger 'villages' or sub-cities such as Shinjuku, Shibuya or Ikebukuro which in turn feed into what is supposed to be the central business district of Marunouchi. But Marunouchi too has its 'village' qualities.

I discovered too the extraordinary beauty of the Japanese hills, right on the outskirts of Tokyo. No one tells you before you come to Japan (or even after, for that matter) that some of Japan's, and the world's, most attractive mountain country can be found in the 1000 to 2500 metre (3280 to 8202 feet) ranges just to the west of Tokyo. Certainly I didn't know, until almost by accident I set off in that direction to find myself a day's hiking. From a small station an hour out of Ikebukuro on the trainline that runs through to the Chichibu foothills I began walking.

Within minutes I was passing through a wonderland. From a small stream at the bottom of the valley the path wound up through rock-walled fields and traditional farmhouses clinging to the steep slopes, past the village temple lined with fat, centuries-old *sugi* (Japanese cedar), up through the planted forests of *hinoki* (Japanese cypress) with the sounds of streams falling away hundreds of metres below, until I came out onto a belt of the original deciduous forest lining the top of a ridge that led through to the main ridge. From there I gazed over rows of more valleys and ridges, each with its tiny villages clustered at the bottom, and extending through to the main Chichibu ranges.

It was a miracle of man blending with environment. And it had all happened naturally, without any grand strategy or plan. Later that day high in the hills I came across a large temple, the Takayama Fudo, where they let me stay the night and showed me the valuable Buddhist carvings and paintings they had been storing for hundreds of years. It wasn't a particularly famous temple, nor did anyone try to advertise it. It simply sat there in the hills quietly going about its business, waiting for the occasional visitor to drop by.

Over my twenty years in Japan I think I have had more than a reasonable share of experiences. But nothing compares with the drama of nature in Japan and its mountains. One feels enveloped by a depth and a richness quite unlike anything to be found elsewhere. The Japanese have the word *shin-pi* to describe it, the feeling of dark and embracing mystery. *Shin* means godlike, and *pi* means secret, and is the same *shin* as in Shinto, the original primitive, animistic religion of Japan which says that gods abound in nature and create its wonders. Climbing in the Japanese hills one often comes across large trees, rocks or waterfalls decorated with Shinto symbols to remind us that the gods are present.

Geography could also help to explain the mysterious attraction of nature in Japan. Japan lies at the junction of three tectonic plates—the North American plate, the Eurasian plate and the Philippine plate—which explains the ceaseless volcanic activity. Many of its mountains are still rising. Climatically too Japan lies at an interface, between the airmasses of the East Asian continent and the Pacific Ocean. In winter the climate is dominated by cold air from Siberia; in summer it is the hot, humid air of the Pacific high pressure system. In the seasons between, the two systems struggle for control, causing a steady circle of rain and sunshine as depressions run from west to east along the Japanese coast. It is this combination of geology and climate that creates those damp, fertile, deeply forested slopes that plunge at almost 90 degree angles to rushing streams below and that is so typical of Japan.

Other geographical factors are simply distance and location. Japan extends a full 3000 kilometres (1864 miles) which covers the sub-arctic and cold–temperate regions of Hokkaido to sub-tropical Okinawa. Tokyo lies at the same latitude as southern Spain or northern Morocco. Much of Japan lies in the belt of lustrous, sub-tropical evergreens—camphors, camellias, etc.—that extends through southern China to Nepal. Bamboos grow freely, almost to Hokkaido. In a semi-deciduous forest south of Tokyo, palm trees grow amidst trees stripped of leaves in mid-winter, 10 metre (33 foot) wild camellias in full bloom and rocks thick with green moss. Heat and moisture, interrupted by the dry, cold Siberian winds of the winter, combine to create a variety and wealth of vegetation rarely found elsewhere.

Gradually I began to extend my weekend walking trips. I 'discovered' the Tanzawa area, a massive clump of granite just to the southwest of Tokyo close to Mt Fuji. To the south lies the highly volcanic Izu peninsula with its hot springs

and high central range looking out over a very blue Pacific. Mt Fuji beckons but the real 'discovery' was a broad 150 kilometre (93 mile) range of 3000 metre (9842 foot) peaks called the Southern Alps just beyond Fuji and easily reached in only three hours from Tokyo.

Ask the average Japanese whether he or she has heard of the Southern Alps, let alone visited them, and the answer will probably be no. Yet they exist in all their sublime beauty, with most of their area still unspoiled by timber cutters and road builders. Rows of peaks with alpine vegetation tower 2000 metres (6562 feet) over gravel-filled rivers plunging to the Pacific. After a big typhoon the streams become moving masses of rock and debris. Yet good tracks survive along the main ridges. Here the hiker can walk for days, camping or staying in abandoned huts, and meet almost no one. And Japan is supposed to be one of the world's most crowded nations. In the past there were more hikers perhaps. But today's Japanese are more sedentary.

That year in Japan—1967/68—was to change many things for me. I discovered not just the beauty of the countryside and the cluttered attraction of the cities; I discovered too that Japan was a much more natural and viable society than I had thought. The professor and his students taught me that the Japanese can be an almost naively simple and friendly people. Indeed naivety—*sunaosa*, or the simple, uncomplicated approach to things—is one of the higher virtues in Japan. I met the woman who would later make a family for me, and like many others before me discovered the strange blend of strength and femininity in the Japanese female. At a local *akachochin* I also began to discover the not unattractive world of the Japanese male.

They call them *akachochin* after the red lanterns that usually hang in front of them. I have described them as eating places but they are really more than that. They are like mini-clubs, with a regular clientele of local citizens who drop in most evenings, usually on the way home from work. Each *akachochin* has its mama-san, or master, who presides over all. The clientele linger for hours over their favourite dishes, often specialties of the house. The atmosphere is convivial, with more drinking than eating.

Near where I lived there was one such *akachochin*. Nightly I would pass its closed doors with the sweet smell of *yakitori* (grilled chicken) and the gentle buzz of conversation seeping into the narrow road outside, and wonder what was

going on inside. I wondered, too, what it would be like to be able to go in and join the 'club', but that was something I assumed to be impossible for us foreigners. After all, if educated Japanese in their firms and universities were exclusivist, then the less educated denizens of the *akachochin* were going to be even more so.

But that couldn't stop me from at least looking inside. As I opened the sliding door slightly, I could see the usual L-shaped counter with seats for no more than seven or eight people. Someone saw me and insisted I come in. Someone else moved up to give me a seat. The mama-san took my order and in halting Japanese I introduced myself. Someone bought me a beer while another character, a close friend of the mama-san I discovered later, went out of his way to talk to me and make me feel at home. No doubt he saw it as his job to boost business.

After a few more visits I began to be treated as a casual member of the 'club'. Then gradually I seemed to have become a regular member. In spring the regular 'members' had a *hanami* (cherry-blossom viewing party) with the mama-san on the banks of the nearby Tama River, which I was expected to attend. When I left to return to Australia a few months later they had a farewell party for me. For someone like myself struggling to break into a corner, any corner, of Japanese society the experience was euphoric.

The Japanese sense of identity, is different from ours. We non-Japanese seek friends on the more 'logical' basis of attribute—people who share the same lifestyle, religion, class, way of thinking as ourselves. So we tend to be more open in our contacts, as we search out those who have the attributes we share. But we can also be fairly rigorous in excluding those who don't share our attributes. For the Japanese identity comes more from location—where one works, is educated or even where one eats and drinks. Those within that location are automatically within the circle of friendship. Those outside are automatically excluded.

We foreigners usually find ourselves outside and assume we are being excluded deliberately, as foreigners, though Japanese are often excluded just as vigorously as ourselves. But if by some chance we find ourselves brought within, as I was in my *akachochin*, the view is completely different. From being a complete outsider one is treated as a complete insider. And this is true even though attributes such as language, appearance, etc., are radically different from those of the Japanese within the group. It is an experience that makes the claims about the Japanese being racist or xenophobic highly questionable. In my own case, it was an experience

that convinced me Japan was a place where I would want to live and work.

True, there were other factors. One of them was the practical rationality of so much in Japanese everyday life—simple food, tatami mats, *shoji* (sliding screen doors), good transport networks and so on. Another was the blessed freedom from the ideological tensions that were tearing our own societies apart at the time. The Japanese, with their highly pragmatic attitude to religion and politics, simply are not interested in the arguments that the rest of us see as so important. For someone like myself who had spent years caught between East–West political pressures, Japan was a haven of peaceful sanity.

In 1969 I found myself with the temporary job of Tokyo correspondent for an Australian newspaper, thrown into the midst of Japan in the final days of what is now known as the high-growth era. I lived and breathed the dynamism of Japan. I was appalled by the unprincipled politics, the opportunism of the diplomacy, and the lack of public morality in some areas. I was delighted by the obvious dedication of the Japanese to the workplace and sense of responsibility in work. I enjoyed, too, the efficiency of the society, the consideration most people paid to each other in daily relations and, contrary to much misreporting abroad, the ease with which information was provided to us curious foreigners. Before long I was drawn into that favourite guessing game of resident foreigners—trying to explain just how and why the Japanese got to be as they were.

With me, though, the game had a twist most other analysts overlooked. Most who come to Japan directly from the West assume that the Japanese, for all their eccentricities, must belong in some way to the Sinitic culture group of China, Korea, Vietnam. After all, so much of Japan's culture came from China. Before coming into formal contact with China and Korea in the early centuries AD, Japan was little more than a collection of primitive tribes and clans without even a writing system. It borrowed heavily from the Chinese language, in much the same way as we Anglo-Saxons borrowed French, Latin and Greek words into our original language. Japan's writing system relied entirely on Chinese ideographs at first, with some ideographs later simplified to create the phonetic script which the Japanese now combine with their Chinese imports (anyone who knows Chinese can understand at least the headlines in a Japanese newspaper). China provided Japan with its systems of central government, law, bureaucracy, religion, economy, philosophy. Even the art, the early Shinto beliefs, and many of the daily living

habits of the Japanese—often seen as uniquely Japanese—in fact owe much to China. Until the beginning of this century a strict training in the Chinese classics was an integral part of the education system. From this it follows that the Japanese personality too must owe a lot to China.

But if one comes to Japan via China, as I did, the argument does not hold. In many ways the Japanese seem to be the mirror opposites of the Chinese. The Chinese dislike cultural imports; the Japanese allow in everything and anything. The influx of foreign words threatens even the language of Japan. The Chinese are confident in dealing with foreigners; the Japanese are not. Put young, modern Chinese in a factory or firm and immediately they begin to think about their career paths, money, promotion, personal interests, just as we Westerners do. Offer them slightly better conditions elsewhere and they will change jobs even more readily than we do. For the groupist-minded Japanese the prestige, image, commitment and loyalties of the workplace are all important; money is secondary.

The Chinese, like ourselves, have a rationalistic mentality. They try to operate on the basis of principles, debate, logic. They rely on laws or ideology to guide them. They seek universals which claim absolute validity, just as we do. Indeed at times their absolutism goes beyond ours, in the legalism of Singapore for example or the Maoism of 1960s China. The Japanese are a more flexible people, negligent even, in their disregard for rationalistic thinking, laws, ideologies. They rely more on convention, rules, mood, or *kuki* (the atmosphere of the moment) to organise their society. Principles have a lowly status, as shown by Japan's now well-studied system of *tatemae* and *honne*. *Tatemae* is the principle, or what one should be doing in a situation. *Honne* is what one actually wants to do—one's basic instinct. We non-Japanese would find it hard to admit a gap so openly.

In particular we have the strange situation of religion in Japan. The Japanese have much the same religious instincts as the rest of us. But they share little of our absolutism. Buddhism imported from China is supposed to be dominant, and there are also hangovers of Confucian influence too. But coexisting with all this is the primitive Shintoism of an earlier Japan. The average Japanese sees no problem in having a Shinto wedding and a Buddhist funeral. Many now also want to have Christian weddings—not out of any great liking for Christianity but because they like the atmosphere and the music. Korea, which also borrowed its religions from China, is much stricter. Confucianism and Buddhism are clearly differentiated.

The original animistic religion is dying out. Many Koreans are attracted by the absolutes of Christianity, unlike the Japanese. When Koreans convert to Christianity they abandon their native religions, again unlike the Japanese.

The other problem for me was explaining the contradictions in Japan. Sometimes the Japanese seem schizophrenic in their opposites. For example, anyone who has spent time in Japan is aware of the extraordinary politeness the Japanese show towards each other. Often that politeness is ritualised but just as often it is real—part of a genuine desire to establish a smooth and friendly relationship with the other party. But the same Japanese can also behave with extraordinary thoughtlessness or even cruelty at times, and we do not have to rely entirely on our wartime memories for examples.

We see Japan as a peaceful, stable nation. In matters of small personal honesty, like returning lost property or handing out correct change, the Japanese are scrupulous to a degree no Western society today could emulate. Yet the same Japanese tolerate in their midst a gangster community of quite frightening power and size. And they have yet to show any sign of guilt for past wartime excesses.

We see the simple symmetry of the traditional Japanese house, the balance of an *ikebana* (flower arrangement), or the conciseness of the haiku poetry and we conclude that the Japanese must have a superior artistic sense. Then we see the vulgarity of roadside hoardings, the littering of public places, the bland 'one-pattern' style of modern architecture, and we wonder if we are talking about the same Japanese race. In the quiet greenery of an old temple they place a garish red bench donated by Coca-Cola. No one seems to notice the contradiction.

We see the Japanese as a highly progressive people, constantly seeking out better ways to do and make things. How else could they have achieved their remarkable economic progress? Yet the same Japanese can be among the most conservative of peoples. They still resist the introduction of summer time, despite its obvious advantages for the nation (Korea, though it lies well to the west of Japan, has its clocks one hour ahead of Japan in the summer months). The Japanese still cling to the cumbersome calendar based on each Emperor's reign. The Emperor system itself shows the conservatism of the Japanese.

The Japanese have a reputation for being closed and chauvinistic. Their exclusivity towards foreigners and foreign enterprises is well known. Yet no other nation is as open to foreign culture. And at times they can also be very open

to foreigners. Even the one seeming absolute of Japanese society—the intense group mentality and pressure for conformity—is broken from time to time by rare individualists. And once outside the group pressure the Japanese can be highly self-centred e.g. the *watakushi* (I or me) novel where everything revolves around the feelings of the author, and the use of English terms such as 'my car', 'my home', and even 'my Japan'.

And so the contradictions continue. Sometimes the Japanese seem completely dominated by authority. At other times they are quite anarchistic. In the early eighties, when what was seen as the humanistic style of Japanese enterprise management was fashionable study in the West, a United States academic wrote a paper called 'Joy on the Factory Floor'. Recently another Western observer wrote an article called 'Fear in the Factory'. Someone must be wrong. Or could it be that both are right?

The more I puzzled over the Japanese personality the more I came back to the concept of the Japanese as a fundamentally emotional people. Emotional is a word many would not use about Japan. They would see the Japanese as artificial and robot-like, with emotions inhibited. If anything they would use the word unemotional.

But emotional has the deeper meaning of acting on the basis of feelings and instinct. We see it in Japan in the constant appeals to the heart, in the emphasis on human relations, in the dislike of dry, reasoned argument. In Japan it is a virtue to be *uetto* (wet) rather than *dorai* (dry). *Jocho*—refined emotionality— is the ultimate in 'wet' virtues. Even intellectuals boast of the non-intellectuality, of how the Japanese prefer intuition and feeling to logic and reason.

Ultimately, too, the group behaviour of the Japanese is an emotional quality. So is the desire for conformity within the group. The individual's unwillingness at times to show emotion is due solely to the deeper emotional imperative that says individual desires should be subservient to the demands of relations with others. Then there is the susceptibility to every variety of *moodo* (mood), *boomu* (boom) and *shokku* (shock). What the society says and thinks at any moment is more important than the dictates of one's own individual judgement.

This society-level emotionalism underlaid, of course, the intensity of Japan's wartime nationalist fervour. Today it still exists but in very different and largely non-nationalist forms. When I arrived in Japan in the mid-sixties the Japanese

were convincing themselves of the coming bowling boom. The relics of that boom, in the form of rusting and deserted bowling palaces, still dot the Japanese countryside. Then we had the golf boom and the land boom of the early seventies, both neatly punctured by the oil shock of 1973, which threw Japan into a deep pessimism and gloom, broken occasionally by the panda boom as the Japanese rediscovered China, the koala boom as they discovered Australia, and the 'internationalisation' boom as they discovered how badly they needed to understand the rest of the world. Then we had the land and the share booms of the mid-eighties that saved the economy but brought such grossly distorting wealth into the hands of many Japanese.

Japan's sentimentalism is another emotional quality, and we see it in everything from the nostalgia for old trains and home cooking, to *karaoke* bars and loyalty to old schoolfriends. In Japan you do not necessarily buy from the cheapest supplier. You buy from people who have faithfully supplied you and looked after you in the past, even if their prices are quite a deal higher.

The world of Japanese advertising is saturated with sentimentality. True, advertising anywhere usually tries to appeal to the emotions rather than the intellect. But outside Japan there is at least some effort to provide objective reasons why one should buy a particular good or service. There is usually some mention of price, for example. In Japan the appeal is almost a hundred per cent emotional. But it is a highly sophisticated emotionality, aimed at providing just the right image and mood. With us non-Japanese, emotion is usually simpler and less refined.

The arts also rely heavily on emotional sophistication. With the rest of us the emotional will to some extent be combined with the intellectual; Shakespeare draws us not just by the beauty of his words but also by the skill of his plots. In Japan we are supposed simply to enjoy the refinement, at times the ultra-refinement, of emotion and feeling. So the careful subtlety of the Japanese garden contrasts with the logic and grandeur of Versailles. Even such seemingly ritualistic arts as *kabuki* or the tea ceremony are, the Japanese tell us, infused with a delicate, concentrated emotion.

But if emotion was the key to Japan, how did this fit in with the obvious pragmatism of the Japanese (another Japanese contradiction perhaps)? And how did one relate it to the other theories about Japan? At the time—the early seventies—Japanese scholars were beginning finally to try to tell us more about how their

society operated. The anthropologist Nakane Chie insisted that the strongly hierarchical and closed nature of the Japanese group explained all else in Japan. But if the Japanese were so hierarchical, how come the egalitarianism often found in the workplace? Another scholar, Doi Takeo, published a book saying the key to Japan was something called *amae*, or passive indulgence, in relations. That too was an emotional quality but it didn't seem to explain everything.

In particular I faced the problem of *why*. If the Japanese are so different from the rest of us then there has to be a reason. The Japanese themselves often say it is because they are a *nôkô*, or agricultural, people. The rest of us are described as hunting peoples, which is supposed to make us more far-ranging, explorative and individualistic in our attitudes. The Japanese also like to see their conservatism, their diligence and their group behaviour as the natural result of being chained for generations to rice cultivation in small, crowded islands.

But Japan is not the only country to practice agriculture or even to grow rice. The Chinese grew rice long before the Japanese, but they are now very dissimilar races. And Japan is not as small as many imagine. It is larger than West Germany in area. If the Japanese live crowded together maybe that is because they like it that way. They leave large areas of usable hillside land unused.

Then there are those who say the uniqueness of Japan is due to the homogeneity of the Japanese as a race. Speaking the same language and sharing the same culture, they are supposed to be able instinctively to co-operate and communicate with each other better than the rest of us can. But are the Japanese really much more homogeneous than, say, the Germans, the French or the English? If anything, regional variations in language and culture are stronger in Japan than in most European nations.

True, one can accept that there is much that is highly instinctive in the way the Japanese communicate and co-operate. Because Japanese in groups ignore the attributes of regional and other differences, they can relate to each other much more closely than we would. But that kind of homogeneity is a result, not a cause, of whatever it is that makes Japan different. We still need to know why in their groups they can ignore the attributes we see as so important.

One day the question occurred to me: Why do we all spend so much time trying to explain Japan? After all, emotional, group-oriented behaviour is something instinctive to us all. We find it in any small group—the family, club

or team. We find it in simple, primitive societies—the village or tribe. We are born with these values. So why can't we stay with them. We non-Japanese assume that our individualism and our rationalism developed naturally as we advanced from our earlier village or tribal values. But maybe it didn't happen that way. Maybe it was a result of something that had happened to us, and hadn't happened to Japan. Japan was simply the village/tribe that had kept on growing. It was us who were different.

Put in these terms, the Japanese puzzle quickly unravelled itself. As a reasonably isolated island nation for most of its history, the one thing that had not happened to Japan was the need to compete and conflict with foreign peoples. So Japan had simply stayed with and refined the simple, emotional, village-style group-oriented values that we all had originally. Gradually it refined those values to create a feudal nation; much of what we see in Japan today could just as well be called feudal or village/tribal. But the group orientated, emotional emphasis remains as it always had.

Meanwhile the rest of us—Chinese, Indians, Arabs, Europeans, etc.—developed our civilisations on the Eurasian mainland, where we had no choice but to be involved in constant war and conflict with foreigners. This had forced us to rely more on absolutes. We had to convince ourselves and others that we were objectively right, and the enemy objectively wrong. We had to rationalise our thinking and our systems of government. We needed strong principles and ideologies as the basis of our societies, particularly if we were in the business of creating empires. The seeds of rationalistic values were sown, and so we began to move away from our original tribal/village values.

At first we were highly dogmatic in our approach. But with time we learned to refine our arguments and our logic. We developed the concepts of science and philosophy. This helped us to progress earlier than Japan. But Japan was then able to borrow the fruits of the more rationalistic values systems—systems of government, science, etc.—first from China and then from the West. Today Japan is getting the best of both worlds—the rationalistic and the emotional.

I use the term emotional, but instinctive might be a better word. This does not mean the Japanese are slaves to crude instinct (though bursts of raw emotion are not unknown in Japanese culture). Rather it means they organise themselves in the same natural way as we all do when we are in primary groups—the tribe,

village or family, for example. In these groups everywhere, we quickly develop rules, conventions and rituals to curb crude instinctive behaviour. Instinctive also embraces both the emotional and the pragmatic. As we react instinctively to the world around us we are sometimes swayed emotionally by feelings. But those same feelings can also lead us to seek practical solutions to problems we encounter.

This concept of the Japanese relying on instinctive, small group values rather than on rationalistic values, allows us to explain the other contradictions of the Japanese. It is not a matter of them being more polite or less polite, more progressive or less progressive, etc. than the rest of us. It is a matter of them, like us, being both polite and impolite etc., but in a different way from ourselves. Sometimes the Japanese are polite instinctively when we would be less polite and we are impressed. But there are also times when the same instinctive values lead them to be impolite when we would be polite, and we are less impressed. Instinctive values lead the Japanese sometimes to be conservative in situations where we would be more progressive, and progressive in situations where we would be conservative, and so on.

In all small groups, people rather than culture serve as the basis of identity. So we are all open to outside culture but exclude outside people. Japan retains the same approach at the level of nation. We go the other way at the level of nation. Conflicts with other peoples encouraged us to see culture as the basis of national identity, so we are exclusivist in this area but more open to outside peoples. Instinctive values encouraged the Japanese to focus their genius on the refinement of small, practical details. Meanwhile, rationalistic values encouraged the rest of us to focus on large conceptual problems, sciences and philosophies. Almost by definition the Japanese will be weak in the areas where we are strong, and strong in the areas where we are weak.

Incidentally, the Japanese are just as bemused by the contradictions they see in us—the way, for example, our ideologies can lead us to be so generous and altruistic at times and so murderous at others, or the scientific brilliance of our intellectuals at times and their impractical dogmatism at other times.

Other island peoples allowed to develop in the same way as the Japanese have ended up with much the same attitudes. In Indonesia or the Philippines, for example, we find strong emphasis on 'Japanese' values such as group co-operation, consensus, and sensitivity in human relations. Indonesia was almost

identical with Japan in the way it blended the civilisations of the Asian mainland—Hinduism, Buddhism, Islam—with its own advanced village/feudal culture. If these island nations of Asia had not been colonised, it is quite possible they would have gone even further in the Japanese direction. Bali and Lombok, the last areas of Indonesia to be colonised, did in fact develop societies very similar to Japan.

Isolated at the other end of the Eurasian landmass, we northern European peoples also developed in ways similar to Japan, especially the island-bound Anglo-Saxons. We too spent a long time following the tribe-village-feudal route. We too developed practicality, craftsmanship and emotional group values to a high level. We too borrowed our rationalism from outside, from southern European and Islamic civilisation. We too combined the two—'village' values and rationalistic values—and made good progress as a result. It is only in recent years that rationalistic values have become strong, and have begun to force us into the same relative decline as we see in the older Eurasian civilisations.

Japan was unique in that it was close enough to a non-aggressive but highly advanced nation such as China to be able to begin absorbing outside civilisation as long as 2000 years ago. Later it was remote enough, and sufficiently advanced in its own feudal society, to be able to avoid colonisation by the more aggressive nations of Europe while absorbing what it needed from European civilisation. So it was able, over a long history, to develop its original village/tribal culture to a very high level, and combine it gradually with the best from two other important civilisations. It is this combination that makes Japan so unusual, and so successful.

Gregory Clark
Tokyo, 1991

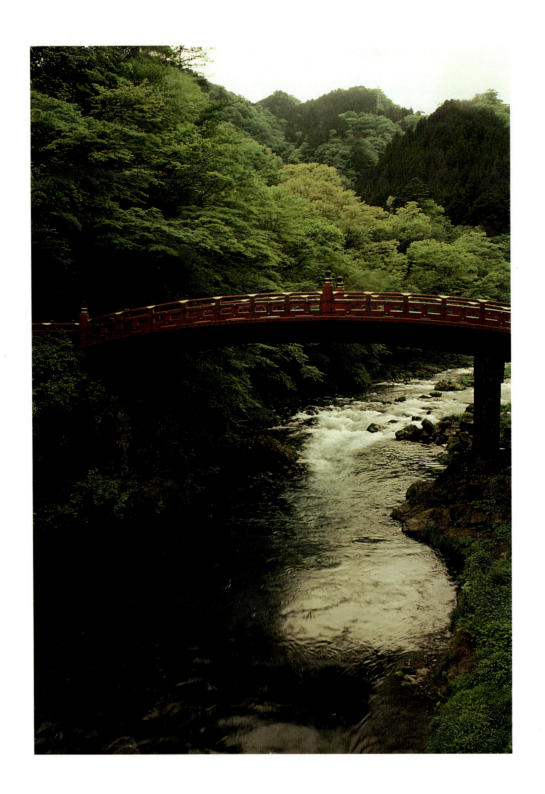

S U M M E R

SOME YEARS THE *tsuyu* (rainy season) comes early to the island of Kyushu and this happened to be such a year. When I arrived at Aso railway station it was raining and the forecast was rain for the next month—and I had twenty-four hours to photograph the area dry.

My luck turned. When I set out on the long walk to Mt Aso at five the next morning, the sky was fine and clear. Not long into my walk I crossed paths with an amateur photographer who offered me a lift in his car and then decided to spend the day acting as my guide. He contacted his wife to explain his predicament: he wouldn't be home until later as he had to help a new friend. And so it was that we spent the day photographing the volcanic activity of Mt Aso, the barley harvest and the many other agricultural aspects of this rich volcanic region. And all without being able to speak a common language.

By 1.30 p.m. I had all the shots I needed and explained to my friend that if it were possible, I would like to catch the afternoon train to Beppu to connect with the ferry to Shikoku. The request threw him into a mild panic as the train was almost due. We arrived at the station as the train drew in and we both realised we had no written details about each other, however, he also realised that the train was about to depart and so pushed me through the gate and onto the train. My friend was left a stranger to me standing on the platform.

Hours later when I had made the ferry, I reflected that a total stranger had helped me and was gone without trace. Just as I was regretting this fact I noticed a note attached to my tickets. My friend and guide had managed to contact the ferry office and pass on to me his name and address. The day was complete.

(Summer opening page) The Shin-kyo (Sacred) Bridge spans the Daiya River in Nikko and leads to the Rinno-ji Temple and Toshogu Shrine.

View of Nara from Wakakusa-yama Hill. Nara was the first permanent capital of Japan (AD710–AD784), and the city in which Buddhism was founded in Japan. The five-storey pagoda in the foreground, which dates from 1426, is part of Kofuku-ji Temple and is the second-largest pagoda in the country.

A summer storm broods over ripening barley fields in the Kumamoto Valley near the foot of Mt Aso in central Kyushu.

(Following page) Two girls picnic in the wooded grounds of Ninna-ji Temple in the northwest of Kyoto. Temples are visited as much for their beautiful gardens, some of which are centuries old, as for their religious and historical importance.

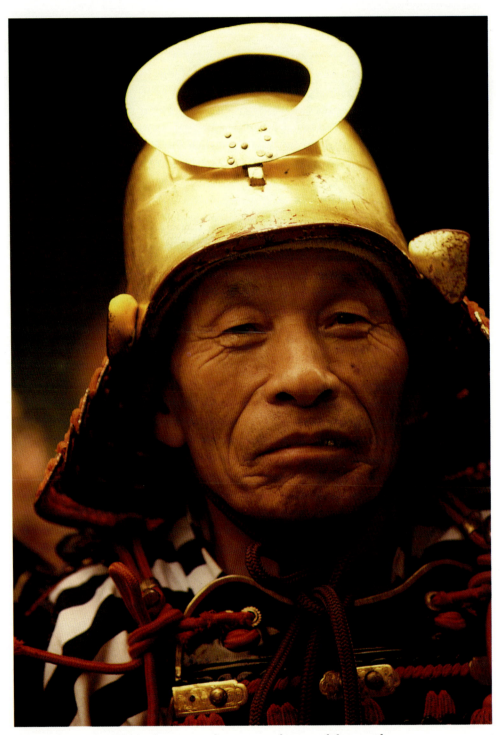

The wearing of traditional costumes forms part of many of the temple
festivals that are celebrated during the year.

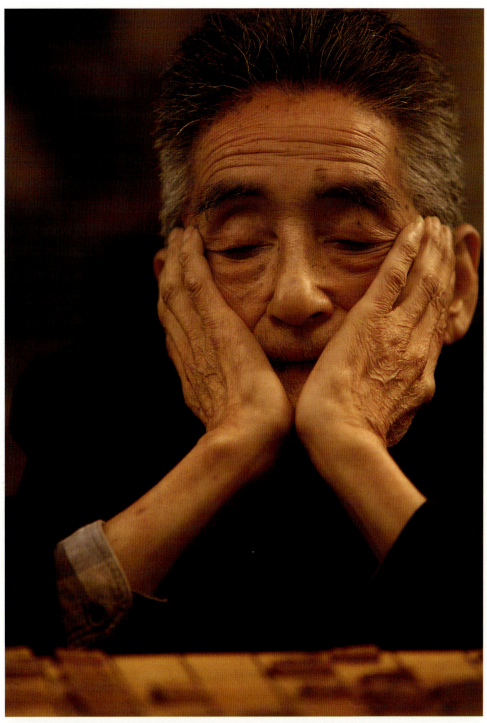

Contemplating a move during a game of checkers in the grounds of
Himeji-jo Castle, Himeji, southern Honshu

A country road near Morioka in the Tohoku area, northeastern Honshu

Formally arranged slippers await patrons of a traditional *kabuki*
theatre in the country town of Uchiko on Shikoku.

A musician plays the traditional accompaniment to a *bunraku* (traditional puppet play) performance. The instrument, a *shamisen*, has no frets, so the musician plays by ear.

The moods of Matsushima Bay make this area one of the traditional
'big three' of Japanese natural scenery.

Tea plantations near Kakogawa, southern Honshu.
Tea was introduced into Japan in the twelfth
century, reputedly by the Zen monk Eisai.

Schoolgirls walking on the slopes of Mt Aso in
central Kyushu during the *tsuyu* (rainy season),
which marks the start of summer in southern Japan.

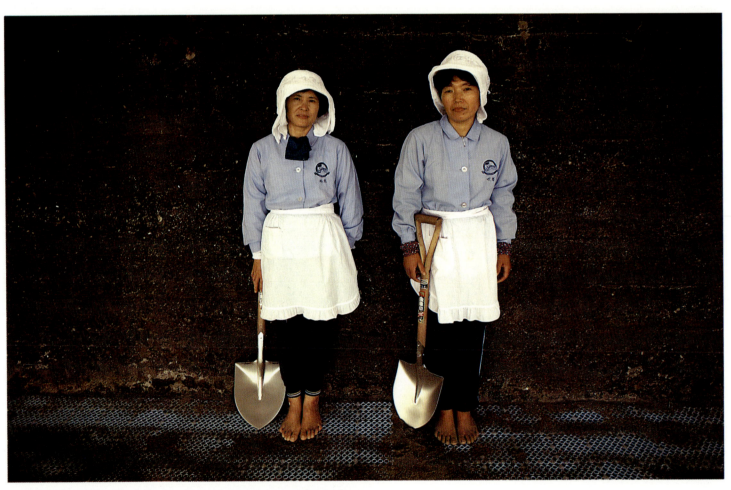

Attendants stand ready to bury patrons (opposite page) in the hot
volcanic sands on the Surigahama Beach. The sands are said to have
medicinal properties and make Ibusuki, southern Kyushu, one of the
most popular hotspring resorts in the country.

Three boys on their way to karate practice pose for a photo beneath Okayama-jo Castle, Okayama. The castle is known as the crow castle because of its black clapboard exterior.

Shinto priests at the Fushimi-Inari Taisha Shrine in Kyoto.

(Following page) A cobbled street in the old Gion district of Kyoto.

A surprise to the foreigner is the abundance of palm trees found in
southern Kyushu, a result of the tropical nature of this part of Japan.
The average yearly temperature for the region is a moderate 18^0C (65^0F).

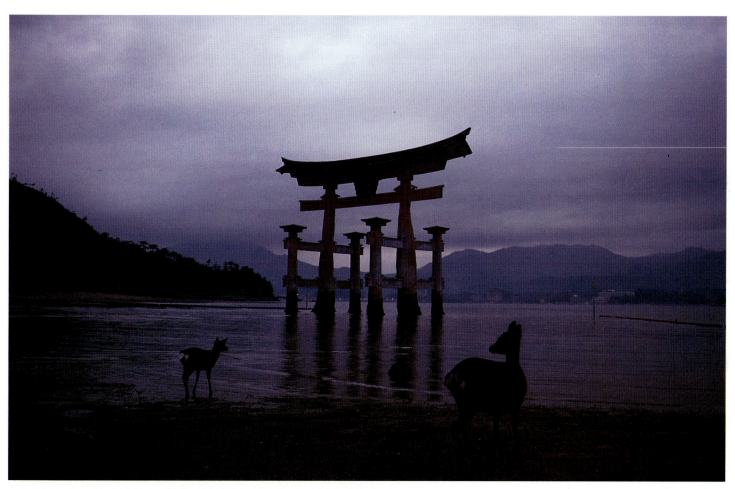

Tame deer roam the shore and woods near the famous *torii* gate off Miya-jima Island (Shrine Island). The gate marks the entrance to the island which has been considered sacred for centuries, and to the Itsukushima-jinja Shrine built in the twelfth century. The island is another of the traditional 'big three' beautiful sights in Japan.

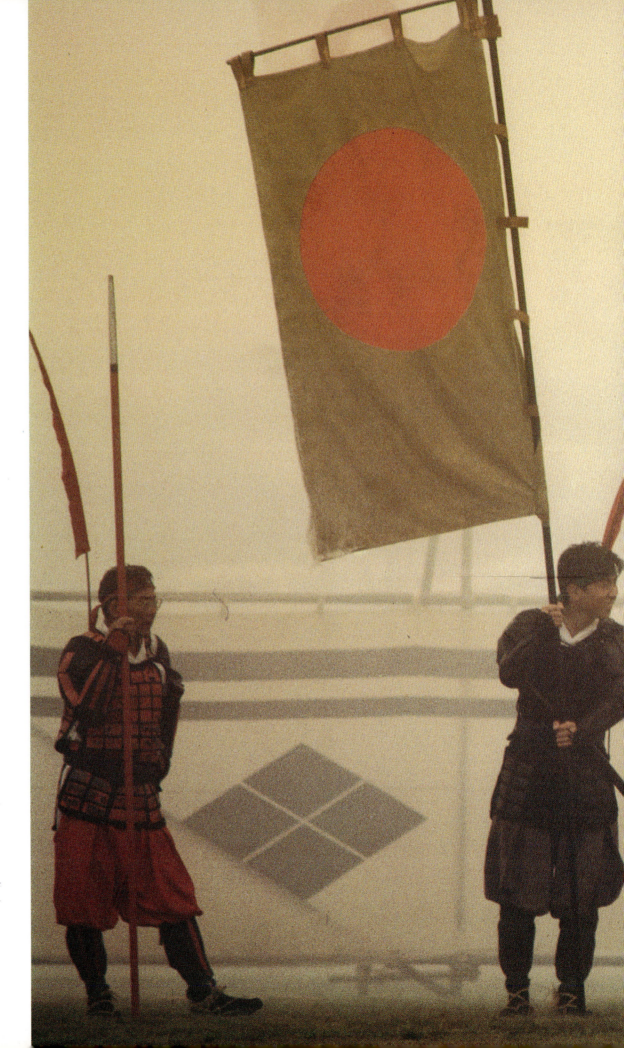

Armour-clad warriors re-enact feudal warfare at the Uesugi Festival in Yonezawa, Yamagata Prefecture.

(Following page) A series of breakwaters protect fishing boat moorings off Surigahama Beach, Ibusuki, southern Kyushu.

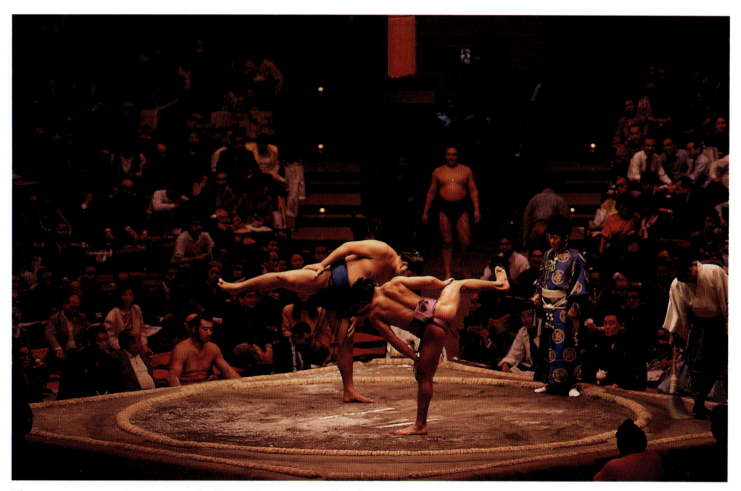

The summer *sumo* tournament at the Kogugikan *sumo* stadium in Tokyo. On each day immediately before the start of the scheduled matches, the colourful *Dohyo-iri* (ring purification) ceremony is performed. *Sumo* stems from a Shinto ceremony in which offerings are made to the gods. In the seventeenth century it developed into a sport and still retains elements of its formal ritual and etiquette. It is so popular that the six seasons held a year are televised and its champions are treated as national heroes.

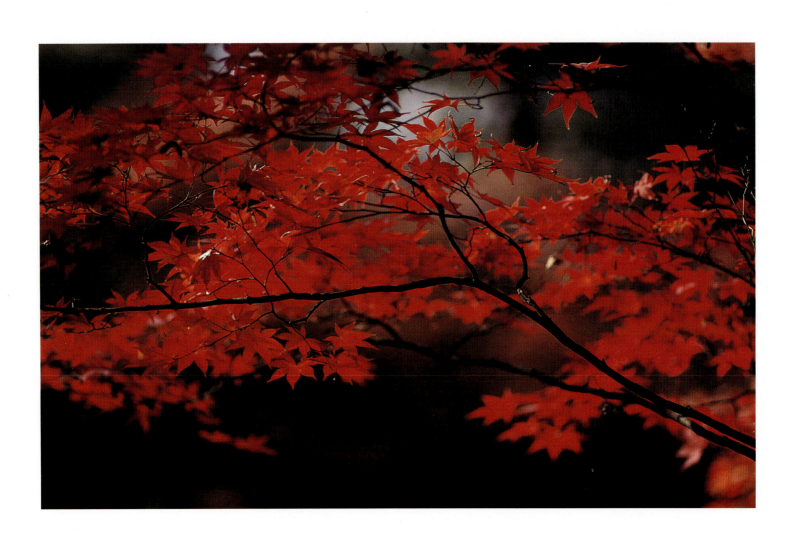

A U T U M N

THE AUTUMN COLOURS of Kyoto are matched nowhere in the world. Every temple has
its own unique splendour of colour and layout that makes you gasp at every turn.
I had been told by an old friend, who had photographed in Japan some twenty
years earlier, that the gate to Komyo-ji Temple on the city outskirts was
particularly impressive at this time of year. I was also warned that although
not many foreigners seem to visit this temple, it was highly prized by Japanese
photographers. I would have to arrive early during peak season should I wish
to gain a good position to use the soft morning light.

Dutifully I arrived early—it was beautiful but not spectacular. I was puzzled. I made
a tour of the grounds and found another gate—my friend was right, it was stunning.
I made myself ready for someone to walk through the scene. Eventually an old couple
moved slowly past, pausing to look back at me photographing them. It was beautiful
with the soft morning light diffused through myriad shades of autumn leaves.

It appeared, however, that my friend had been wrong about the crowd of
photographers, I had it all to myself that morning. Later, when I had finished my
work I walked through the gate. On the other side leading down the hill, both sides of
the path were packed with photographers, at some points three deep and others forced
back into the foliage. Obviously this was the angle to photograph from. I was still
getting to know Japan.

(Autumn opening page) Autumn in Kyoto

The entrance gate to the Komyo-ji Temple in south
Kyoto during the height of autumn. Autumn is one
of the favoured times for temple visiting and
holidays.

A tranquil autumn scene at the Jakko-in Temple at Ohara,
northeast of Kyoto

Autumn in Kyoto Prefecture

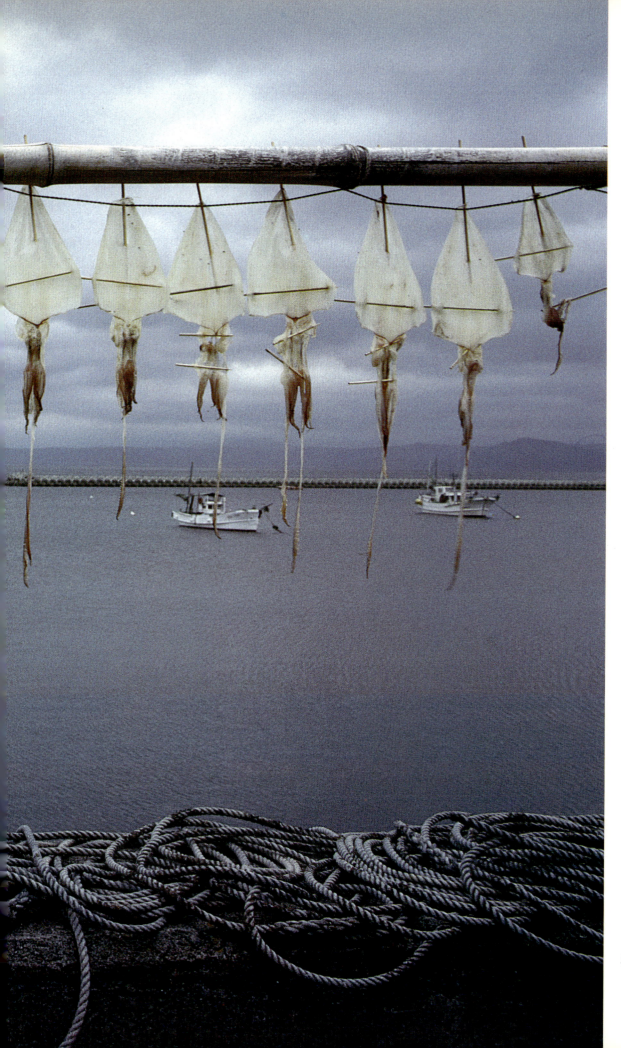

Squid drying in Ibusuki, southern Kyushu

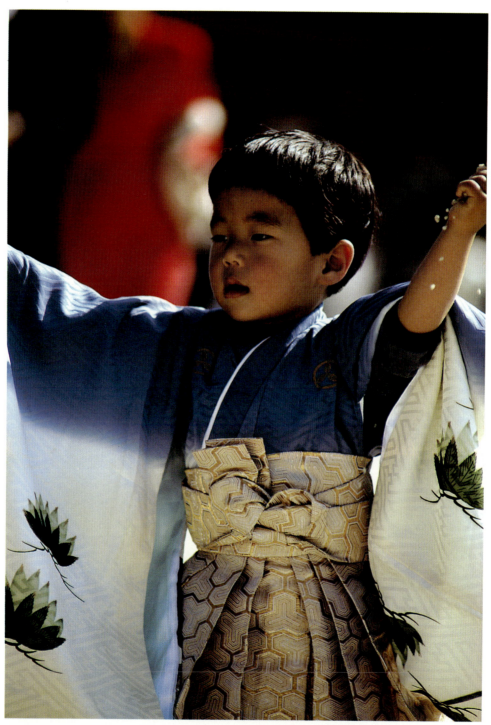

Children at the Heian-jinku Shrine in Kyoto during the 7, 5, 3,
Festival. Traditionally the ages of three, five and seven were regarded as
significant stages in a child's life. At three, children were first allowed
to grow their hair long; at five, boys were allowed to wear the *hakama*,
the wide-legged trousers that are an essential part of a man's formal
kimono; and at seven, girls could wear *obi* (sashes, often beautifully
decorated) with their *kimonos* instead of cords.

Schoolboys pose for a class photograph while at Kofuku-ji Temple in Nara Park, Nara. Most high school children wear this military-style uniform and they are seen *en masse* at historical sites throughout Japan.

(Following page) The fire ceremony at the Fushimi-Inari Taisha Shrine, Kyoto. Originally this shrine was dedicated to the goddess of rice and cereals, however, with the rise of commerce and industry the shrine has become a place to pray and give thanks for good fortune and prosperity. During this ancient ceremony the wishes of forty thousand of the faithful, which are written on wooden chips, are burnt by Shinto priests.

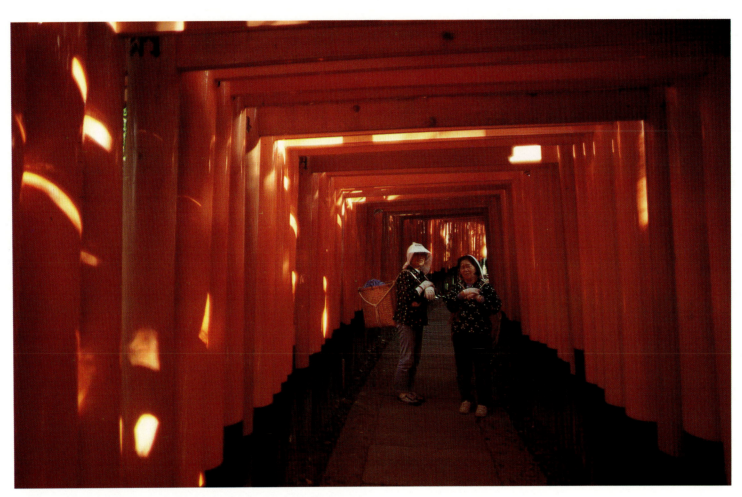

Over the years worshippers have donated numerous *torii* gates to
Fushimi-Inari Taisha Shrine so that now they form an impressive
approach to the shrine.

Every year visitors come especially to Ohara to view its beautiful
autumn scenery.

Restaurant on the Hozu River, west of Kyoto

(Opposite) The steep yet graceful arches of the Kintai-kyo (Sash of Silver Brocade) Bridge

Fishing boats in Kagoshima Bay, southern Kyushu

Bathers at the Tamagawa *onsen* (hotspring resort) on the Hachimantai
Plateau. Communal bathing is not restricted to hotspring resorts but is
a daily occurrence in most urban areas of Japan where many private
houses do not have their own bath facilities. The baths are also a place
for relaxation and social chats.

(Following page) A security guard on duty in the forecourt at the
Meiji-jingu Shrine in Tokyo. The shrine is considered the finest in the
country and was built to honour Emperor Meiji whose forty-five year
reign (1867-1912) ushered in industrialisation and the creation of the
modern Japanese state.

A young *maiko* (apprentice *geisha*) in the grounds of the Chion-in Temple in Kyoto. *Maiko* wear colourful and elaborate *kimonos* until they graduate to the sombre browns and greys of the *geisha*. After emperors became the puppet rulers of the *shoguns* (warlords), the political capital moved from Kyoto to Edo (Tokyo). Kyoto then became the capital of refined artistic expression and the tradition of *geisha* entertainment developed in Gion.

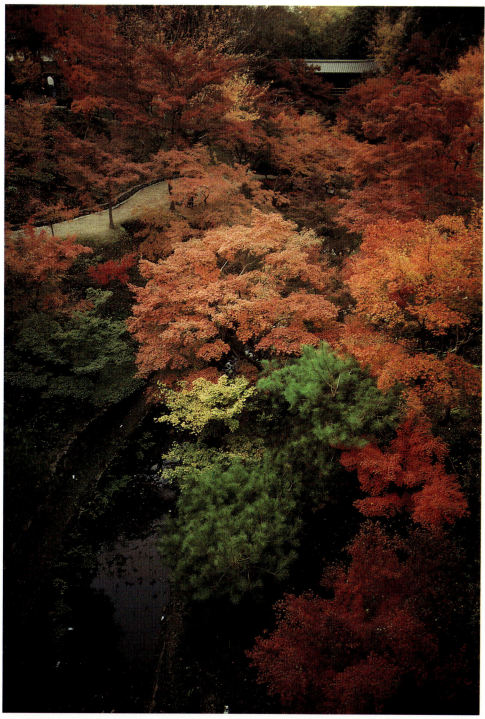

A quiet moment at Tofuku-ji Temple in Kyoto. Normally the grounds
are crowded with visitors wishing to catch the gardens in their peak
autumn colours.

A wedding at the Heian-jinku Shrine at Kyoto

Children celebrating the 7, 5, 3 Festival at Heian-jinku Shrine in Kyoto

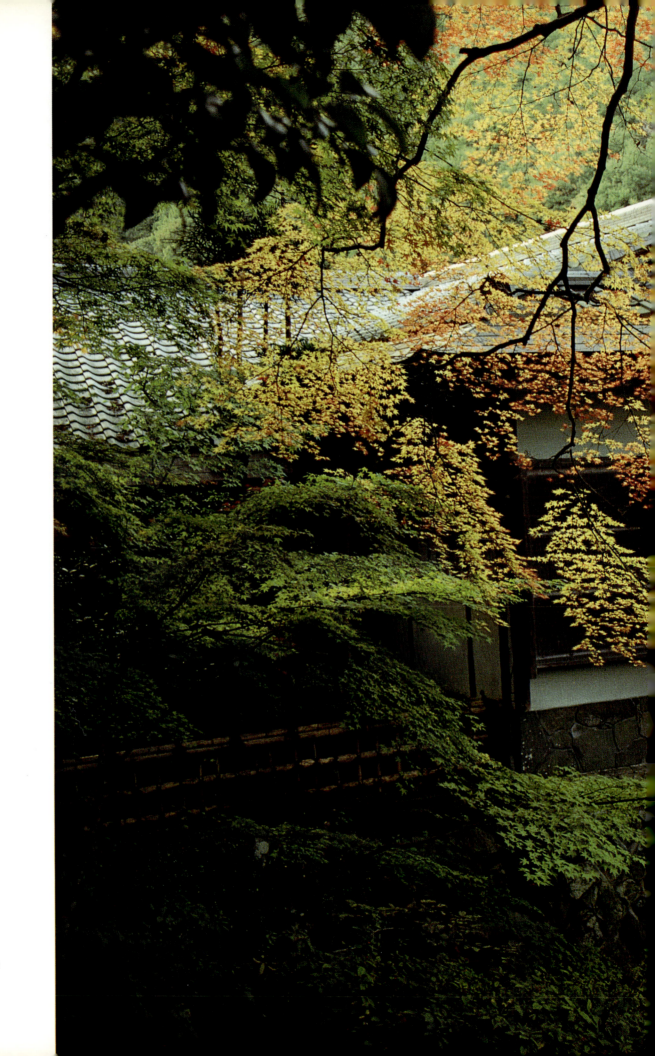

A teahouse in the countryside outside of Kyoto

A tea picker near Kakogawa in southern Honshu

The fishermen near Hiranai in northern Honshu use shells to weight their nets. These women are preparing the shells and tying them to the nets.

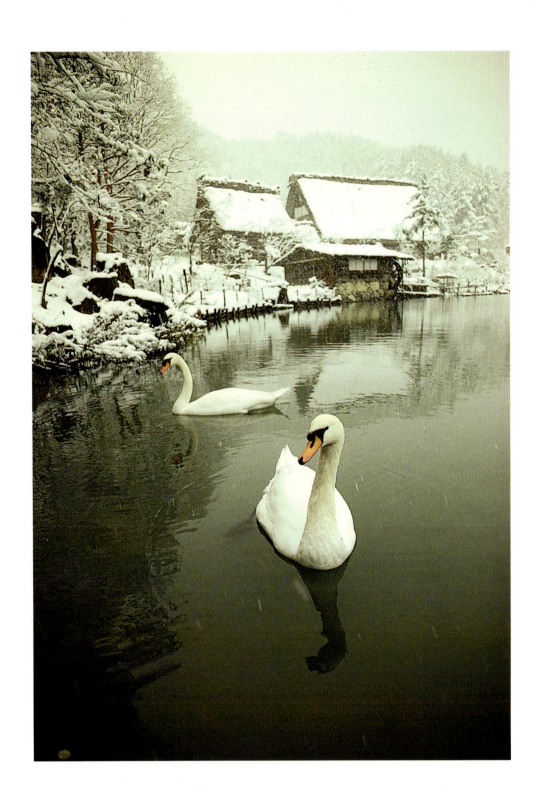

W I N T E R

SNOW COVERED THE COUNTRYSIDE near the town of Shintoku in central Hokkaido. A diminutive old Japanese lady dressed in black was collecting larch branches which had fallen during a recent storm. She was the first person I had seen in the landscape for several days as it had been intensely cold. The scene was perfect, however, it was almost dark, I was cold and tired and I let the shot go and returned to Furano.

All the way back I scolded myself for not pursuing the photograph. The more I thought about it, the more I became determined to return the next day. Back in Furano, armed with my translation book, I wrote out my request in Japanese. However, not being confident of my abilities, I sought counsel at a local restaurant where the manageress spoke a little English. She couldn't understand a word I had written and the evening became a series of hilarious charades during which my story unfolded and my message was rewritten.

The following morning I was on the first train back to Shintoku. After an hour-long trudge back to the area, I found the lady's tracks and followed them to a nearby farmhouse. I knocked timidly on the door and presented the note with an encouraging smile. She read it slowly, then looked at me and replied with an emphatic no. The door closed immediately. The winters are hard in northern Japan.

(Winter opening page) The mill pond at Hida Folklore Village, Takayama.

The first fall of winter snow blankets the ground near the town of Takayama in the Japan Alps.

A snow storm near the town of Biei in the Furano Valley, central Hokkaido. Such storms are a familiar occurrence in this part of Japan.

Farm buildings near Biei, Hokkaido

Traditional farmhouses at the Hida Folklore Village near Takayama in the Japan Alps. The village is a remarkable example of building conservation and includes thirty traditional farmhouses, mills and barns, many of which were transported from other parts of the region. Even in summer small fires are kept burning in the old fireplaces as the smoke helps to preserve the wood.

Farmers come from surrounding villages in the Japan Alps to sell their produce at the early morning markets in Takayama, central Honshu.

The 4.15 p.m. from Biei is about to depart for
Furano. The trains—like most public transport in
Japan—run like clockwork with the drivers counting
down the seconds before starting their service.

(Following page) The weather does not deter
shoppers and funseekers from visiting downtown
Sapporo, Hokkaido, even when transport is by the
ever popular bicycle.

Yukara-no-Sato, a traditional Ainu village near Noboribetsu
on Hokkaido. The origins of the Ainu remain unclear but
they have a different language and culture to the Japanese.
For the most part they have been integrated into Japanese
society and moves are being made to preserve their language.

Larch trees in the foothills of Mt Daisetsuzan
(Great Snowy Mountain), Hokkaido

Winter fields in the Daitsetsuzan region, Hokkaido

The Red Crested White Crane is the symbol of Hokkaido
Prefecture and makes its nest in the marshlands near the Tancho-
zuru Natural Park.

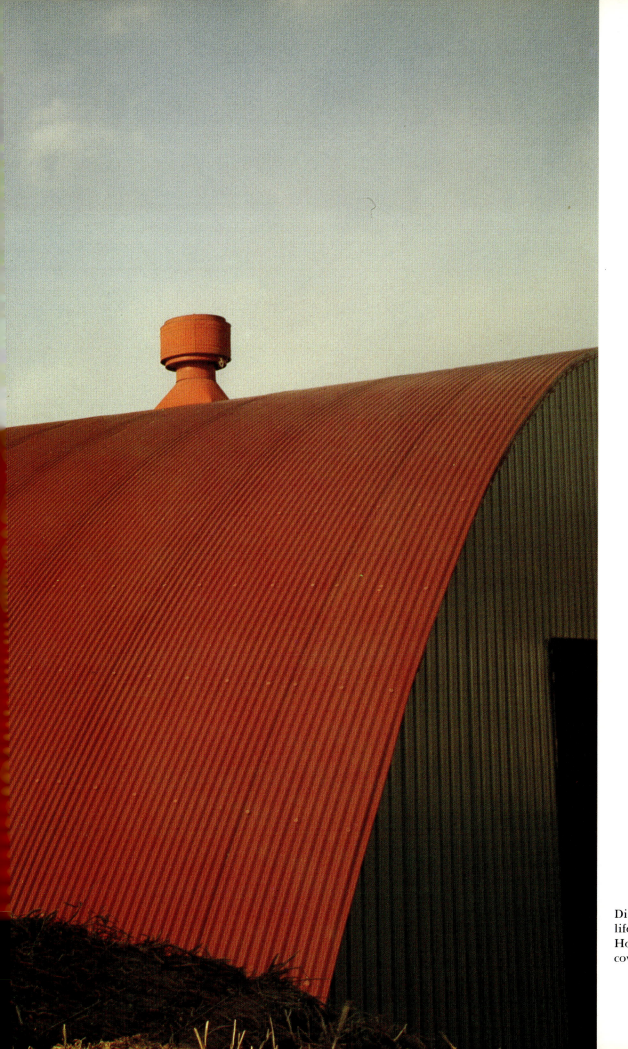

Distributing fodder is an essential part of winter farm life in northern Japan, especially in the Akan area of Hokkaido where the ground is frozen and snow-covered for four months of the year.

Despite its location, the fishing port of Noboribetsu on Hokkaido
remains open all year. Although the port is often snow covered, it
escapes the arctic pack-ice that affects the northern part of the island.

Meeting the early morning fleet, Noboribetsu

Restaurant lanterns line the bank of the Takano River in Kyoto.

Dusk descends over the snow-clad town of Furaňo in central Hokkaido.
Furano is typical of rural service towns in this part of the country.

Construction workers at the Tamagawa *onsen* (hotspring resort) build a new duct that will bring natural boiling water for the baths.

A farmer in the Akan area of Hokkaido. There is a strong American influence in Hokkaido farming techniques that stems from an agricultural college in Sapporo that was founded by an American just after the Second World War.

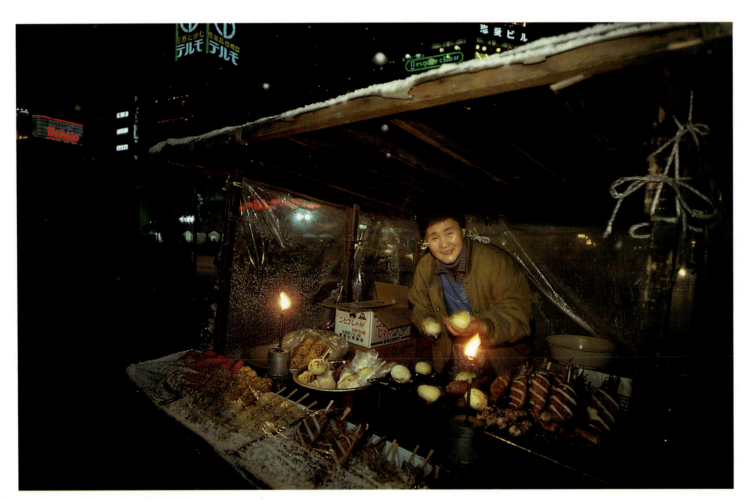

A street vendor sells a variety of enticing hot food on a cold winter's
night in downtown Sapporo.

Late night in chilly Furano. The steam comes from one of the many restaurants in this back street.

Potential customers consider the merits of a restaurant in Kurashiki. The town has a history of grand culture dating back to the Edo period (1604-1858).

(Following page) Even with bare trees the marshlands near the Tancho-zuru Natural Park have a beauty of their own.

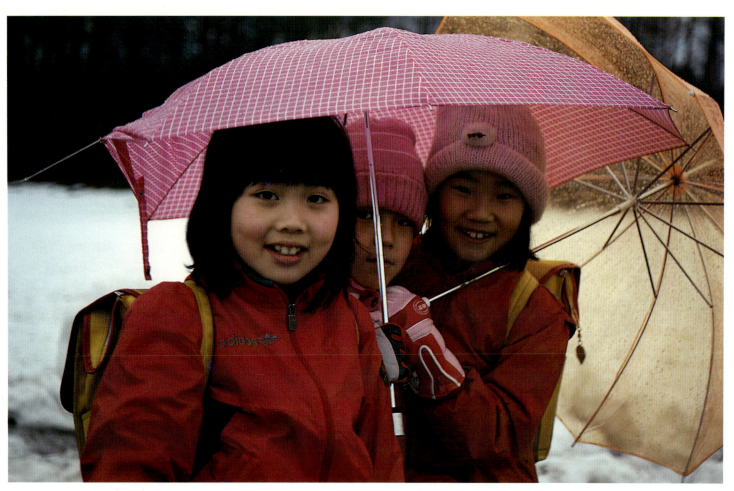

School children near Shintoku in central Hokkaido

A lone schoolboy makes his way home through the snow at Kami-Furano, central Hokkaido.

S P R I N G

I HAD ARRIVED IN KATSUYAMA to photograph the Japanese symbols of spring—Mt Fuji and *sakura* (cherry blossoms). My research had been accurate and the *sakura* were due to bloom in the next few days. For the moment, though, it was raining and the low and all enveloping cloud made it impossible to tell in which direction Mt Fuji lay.

The rain continued to fall as I set out to find the best location to supply the desired elements. Not knowing where the mountain actually was made this an interesting experience, but with the aid of maps and guidebooks I located a place on the shores of Lake Kawaguchi-ko.

The next morning was clear and I set out to my secret location an hour before sunrise, just to be sure. As I made my way through the darkness to the place on the lake, I couldn't believe my eyes—there ahead of me, in my special place, were thirty or forty Japanese photographers already set up and waiting for sunrise on Mt Fuji with cherry blossom. I joined the *milieu* and got my photograph—it was spring in Japan.

Photographers flock into the Fuji Five Lakes district to catch that special spring moment. These photographers have been waiting since dawn at Lake Kawaguchi-ko for a perfect arrangement of light, cherry blossoms and a snow-capped Mt Fuji.

(Spring opening page) Rice planting in the fertile valley formed from the crater of volcanic Mt Aso in central Kyushu. The outer crater of this valley measures 206 kilometres (128 miles) in circumference making it the largest volcanic crater in the world.

The classic shot

Two *kendo* masters practise their art in the grounds of the Seibukan martial arts centre in Kyoto. One of the most popular traditional forms of martial art taught in Japan, *kendo* originates in the expert swordsmanship of the *samurai* warriors. Now bamboo poles have replaced the famous swords.

(Left) A famous *kodo* drummer performs in Tokyo.

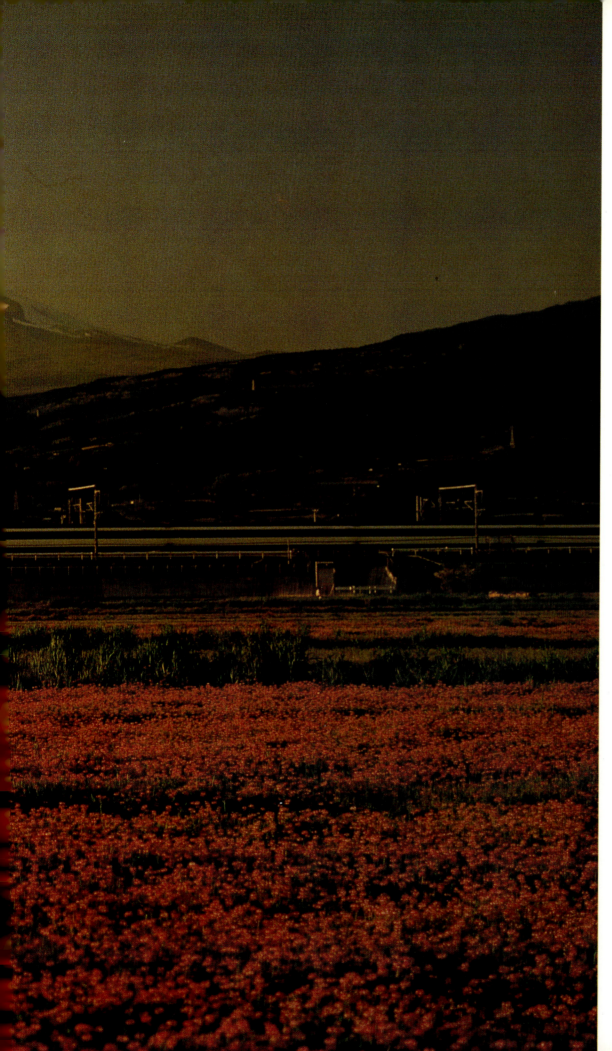

The *shinkansen* (bullet train) flashes past Mt Fuji near Shin Fuji in central Honshu, a view encapsulating icons of ancient and modern Japan.

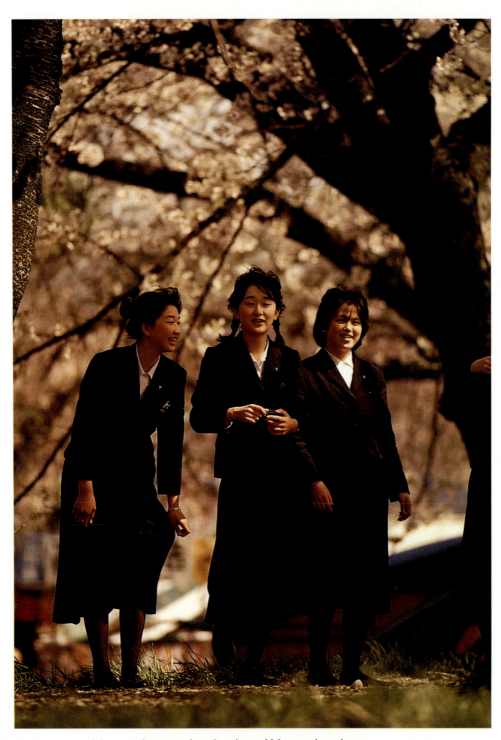

Making a special excursion to enjoy the view of blossoming cherry trees has long been a custom. Family groups and friends plan visits to favourite sites for parties, picnics or to walk among the trees. Here schoolgirls walk under the famous *sakura* (cherry blossoms) of Kakunodate in northern Honshu.

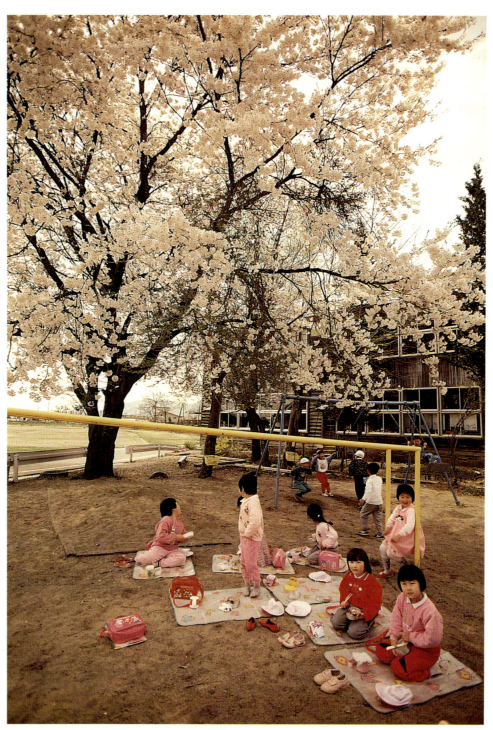

Pre-schoolers, dressed in their best spring pinks, picnic under Kakunodate's blossoms.

Boating on the Hirosaki Castle moat in northern Honshu is particularly popular during the cherry blossom season.

(Following page) An early morning fisherman at Lake Kawaguchi-ko in the Fuji Five Lakes district.

A traditionally dressed falconer at the spring festival of the Toshogu Shrine in Nikko. The festival is noted for its procession of a thousand people wearing various forms of ancient costume.

Yabusame (horseback archery) at Kamakura's spring festival.
Kamakura was once a seat of feudal government and is renowned for
its many old temples, shrines and well-preserved historical treasures.
Writers and poets have also found Kamakura conducive to their art,
and luminaries such as Yosunari Kawabata and Yukio Mishima
spent time here.

Four hundred grand old weeping cherry trees line the banks of the Hinokinai-gawa River in Kakunodate, creating a 2-kilometre cloud of cherry blossoms in spring. One hundred and fifty-three of these trees have been registered as natural living treasures.

Carp kites fly over a hilltop near Adachi in Fukushima Prefecture, northern Honshu, in celebration of Children's Day in May. These kites fly all over Japan on this day and also will be seen anywhere in the world where there are Japanese communities.

A farmhouse in Uchiko, on Shikoku, reveals the classic simplicity of Japanese architecture.

A temple administrator at the Fushimi-Inari Taisha Shrine in Kyoto.

(Following page) A watermelon farmer in Yamagawa, south Kyushu, examines his produce before it is transported to markets throughout Japan. Yamagawa is famous for its tropical fruits, and, with the aid of greenhouses during the winter months, it is able to supply fruit all through the year.

A spring bride bows her head during a Shinto wedding ceremony at the
Heian-jinku Shrine in Kyoto. Despite the extreme cost of such
ceremonies, they are very popular and bookings must be made up to a
year in advance.

The formal wedding party photographed in the grounds of the Heian-
jinku Shrine in Kyoto.

Country people relax with a game of croquet in Yamagawa.

Fallen petals float delicately over the reflection of Hirosaki Castle on
the castle moat. The moat is lined with numerous weeping cherry trees.

Sacred carp at the Koganeyama-jima Shrine on Kinkazan Island, off the northwestern Honshu coast.

Technical Details

The cameras used were two Canon F1 bodies, a Canon 20mm F2.8 lens, a Canon 28-85mm F4 zoom lens, a Canon 200mm 2.8 lens and a Canon 300mm F4 lens. Most of the photographs were taken with either the 20mm or the 300mm lenses. A Metz CT45-5 flash was used as a fill flash with various filters in low light situations while in the day-time, where necessary, a gold reflector was used. I also use a tripod and a cable release whenever possible. The film used was exclusively Kodachrome 64 ASA professional film—known as PKR. The processing was all done at the Kodak Imagica lab. in Shinjuku, Tokyo.

I would like to express special thanks to Anne Adams who assisted me in Japan during the spring shoot and who provided true friendship and understanding when times were difficult.

一六萬円也　榊原至津枝殿

五萬円也　武内　勇殿

五萬円也　石田　功殿

参拾萬円也　渡辺暁仁殿

七拾萬円也　渡辺洞暁殿

壹百萬円也　柴田俊樹殿

壹拾八萬弐千両　西方寺檀徒一同殿

壹拾八萬弐千両　三尊寺檀徒一同殿

参百参拾九萬四阡円　浄土寺檀徒一同殿

大拾八萬五阡円　西方寺檀徒一同殿

六拾六萬円也　安養寺檀徒一同殿

金七拾八萬円也　浄土寺檀徒一同殿

金壹百萬円也　誓弘寺檀徒一同殿

金壹拾萬円也　鈴木譚美殿

金六拾萬也　小野隆秀殿

金六拾萬也　護念寺旦徒殿

金壹拾萬也　神楽寺旦徒殿

金九萬円也　神楽寺旦徒殿

金五萬円也　岩田ハツヨ殿

金五萬円也　谷田博司殿

金壹拾萬円也　木村慶雄殿

金六拾萬円也　漆間朋道殿

金五萬円也　大浦朝子殿

金壹百八拾六萬